Copyright © 2018 Vivid Publishers / Chinthaka Herath
Illustrated by Chinthaka Herath
Design & layout by Intense Media

All rights reserved. No part of this publication may be reproduced, distributed or transmitted in any form or by any means including photocopying, recording or other electronic or mechanical methods, without the prior written permission of the Publisher/ Chinthaka Herath.

ISBN-13: 9781790477906

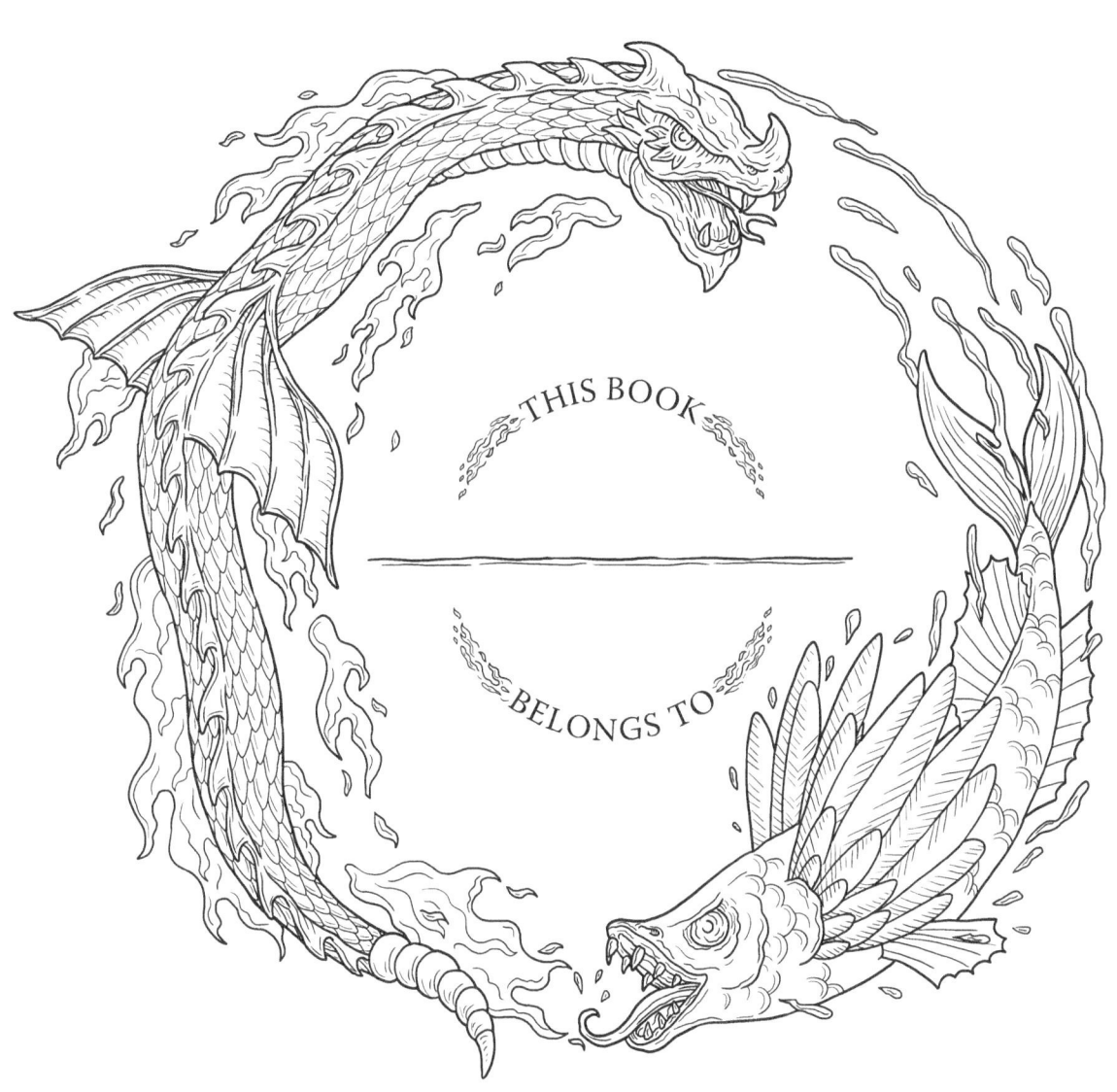

INTRODUCTION

Thank you for purchasing Saga: Fire & Water! This new adult coloring book by Illustrator Chinthaka Herath of the August Reverie series takes a different narrative in terms of the themes explored. For one, you'll be following the stories of two dames from both ends of the book along with their companions as they face their destiny right at the center of the pages!

You'll be encountering many mythical creatures of land & sea along the way, in addition to other intriguing characters.

This book contains twenty five detailed mythical fantasy art illustrations for your coloring pleasure.

All art is hand drawn & line art shading is included as a guide to add shadowing & lighting.

You can use any coloring medium from pencils to markers as long as they have a fine tip.

A note on the use of markers: Even though the illustrations are printed one per page, to give additional protection please place a thick paper or cardboard beneath the page you are coloring so that the ink will not bleed through to the next page.

Subscribe at our website to get a FREE PDF Sampler featuring pages from our other adult coloring book releases! Plus, news on discounts, free pages, contests and more!

 www.vividpublishers.com

We would love to see your completed art. You can reach us at:

 fb.com/VividPublishers @VividPublishers

Also, we welcome you to join our Facebook group to share your art, see other colorists' art, enter exciting contests plus more!

 fb.com/groups/VividPublishers

Thank you for your continued support and interest in our adult coloring books. We hope you enjoy coloring the pages as much as we did creating them. Happy Coloring!

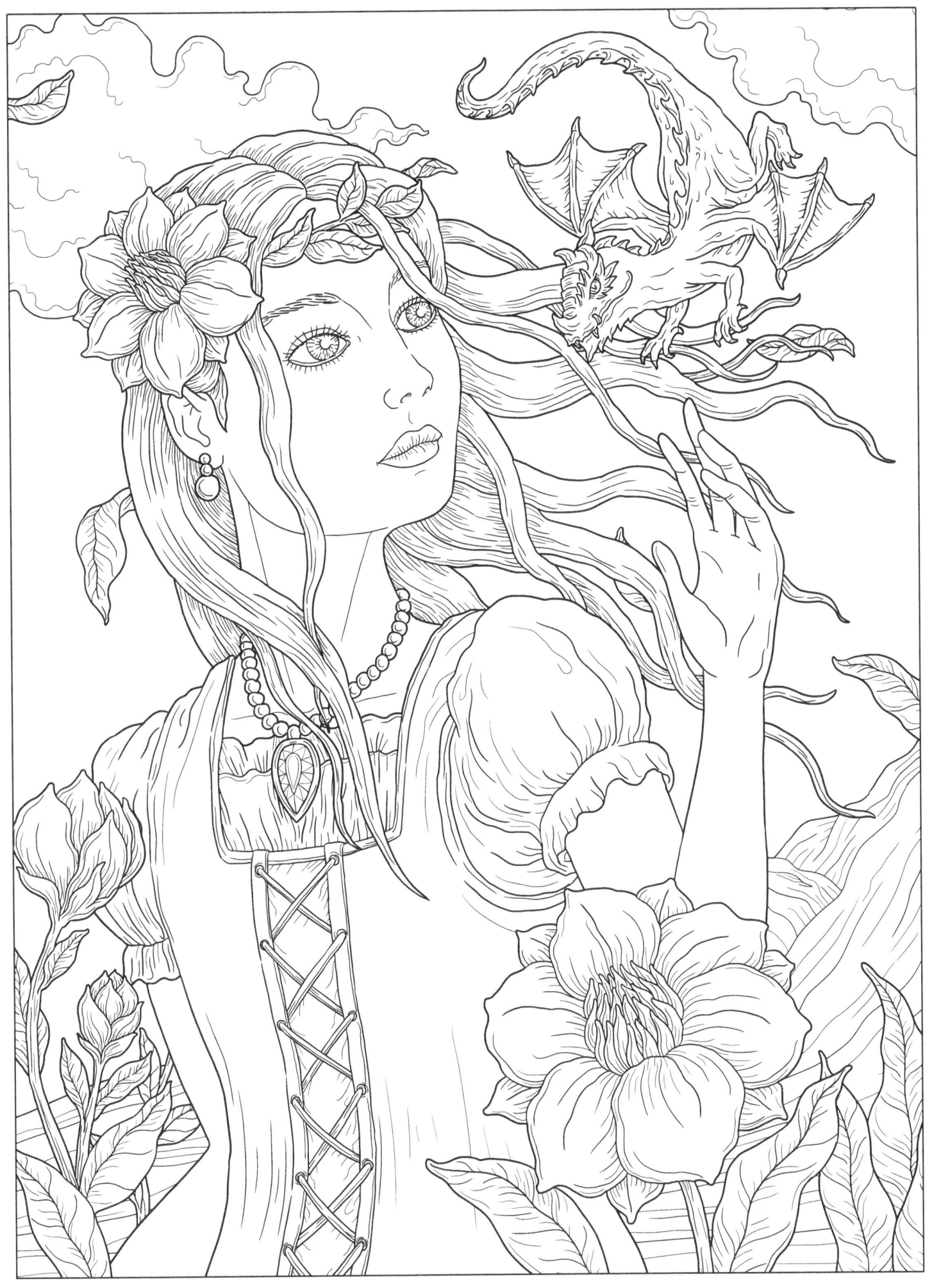

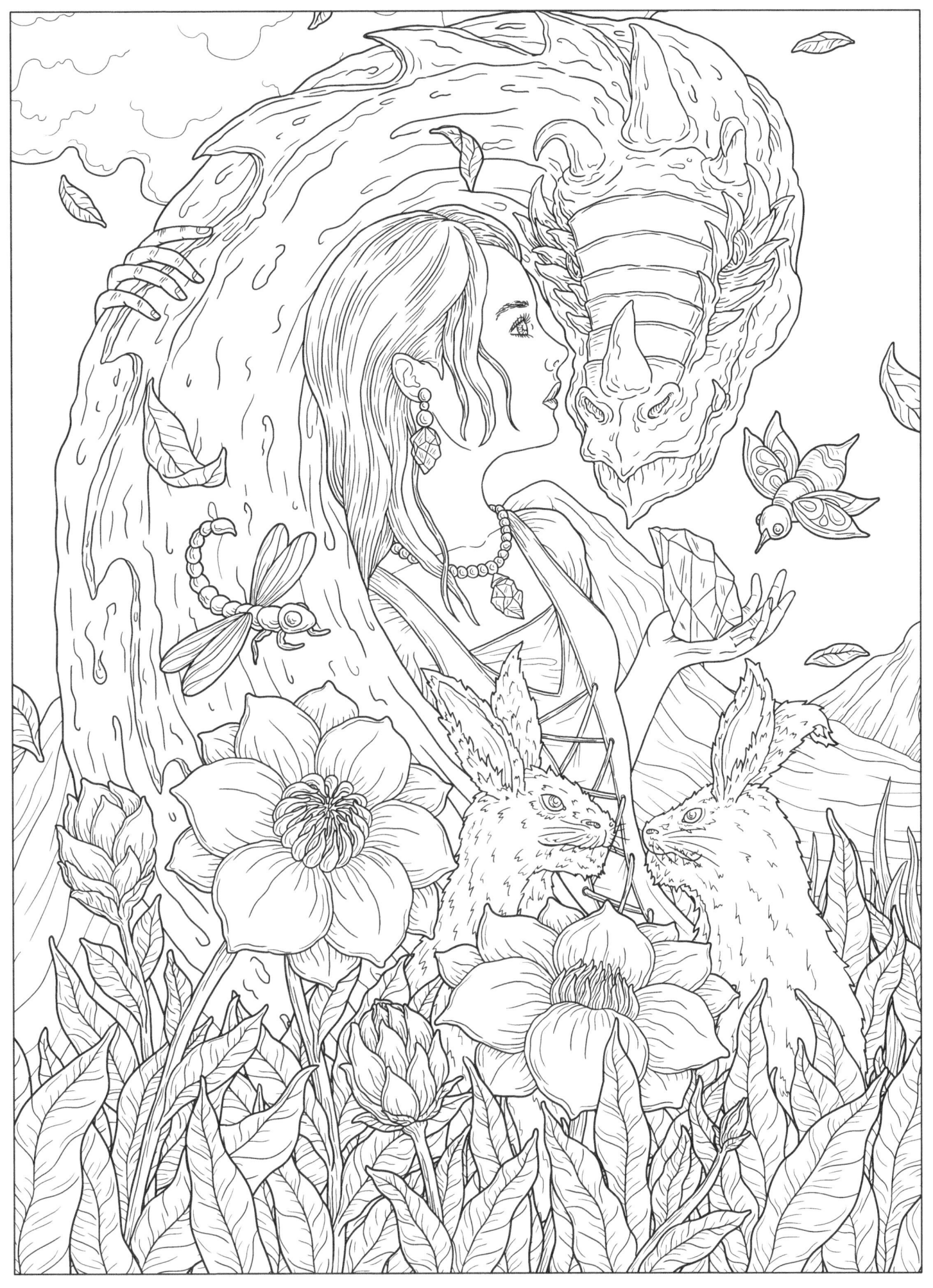

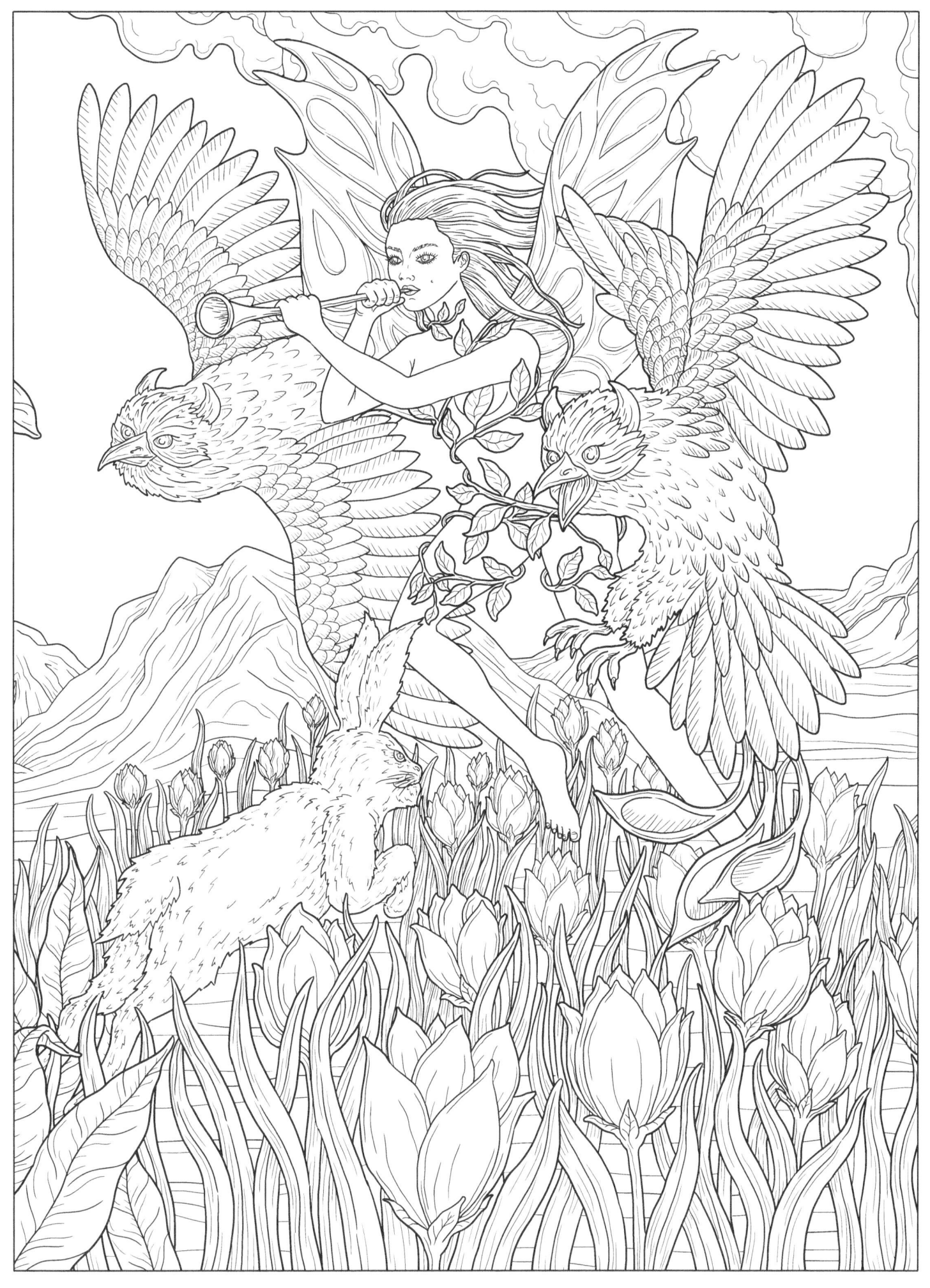

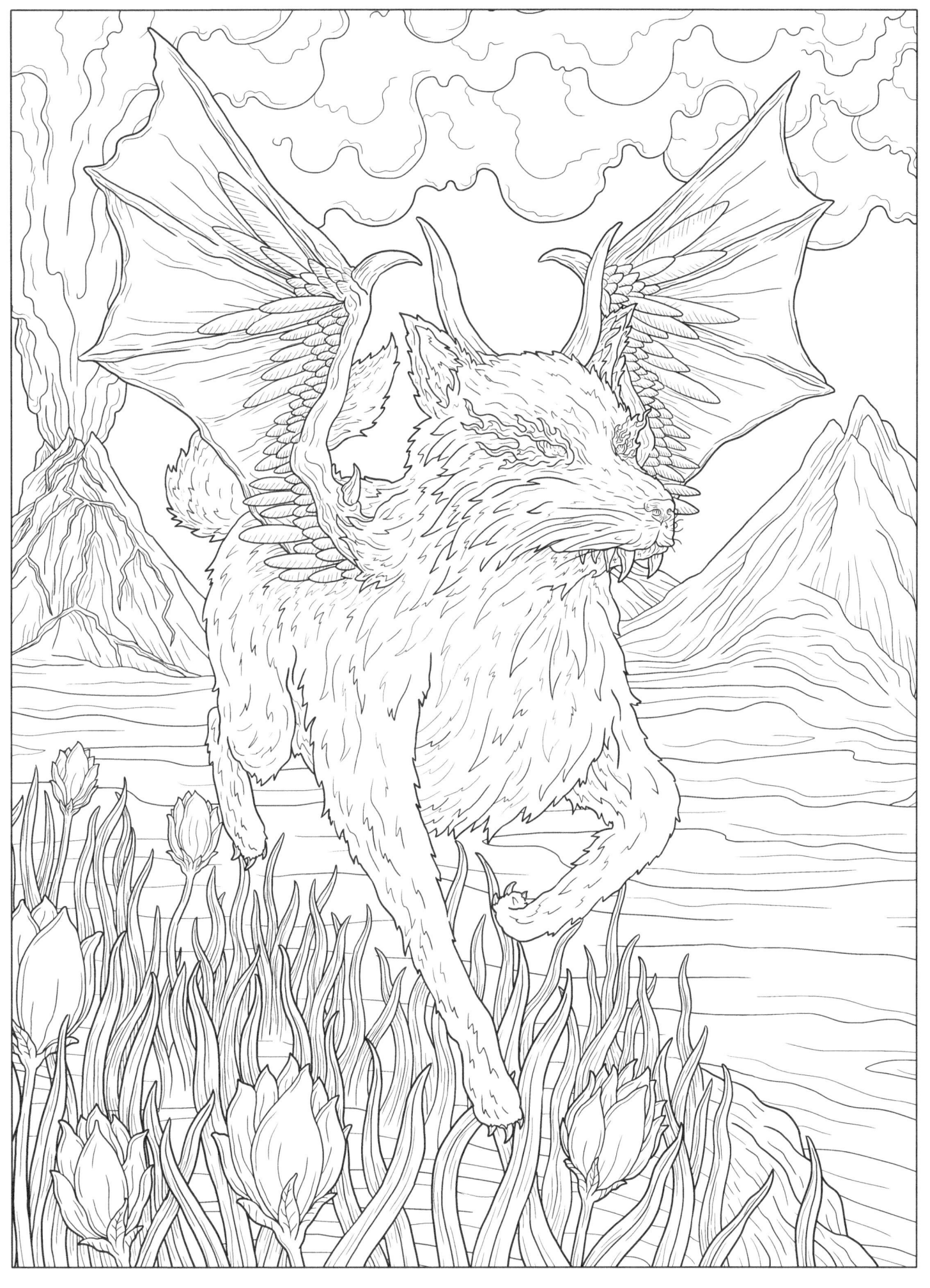

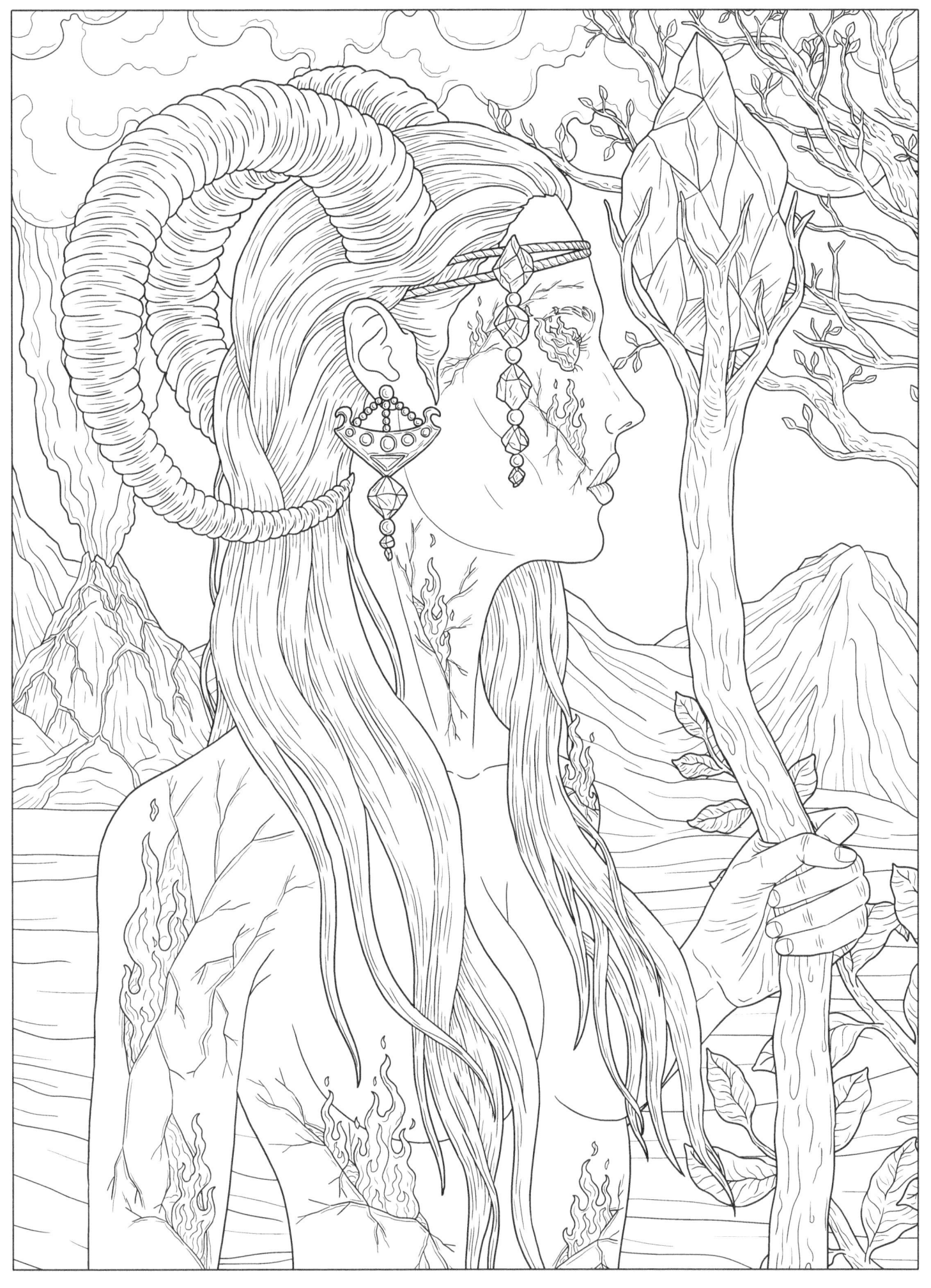

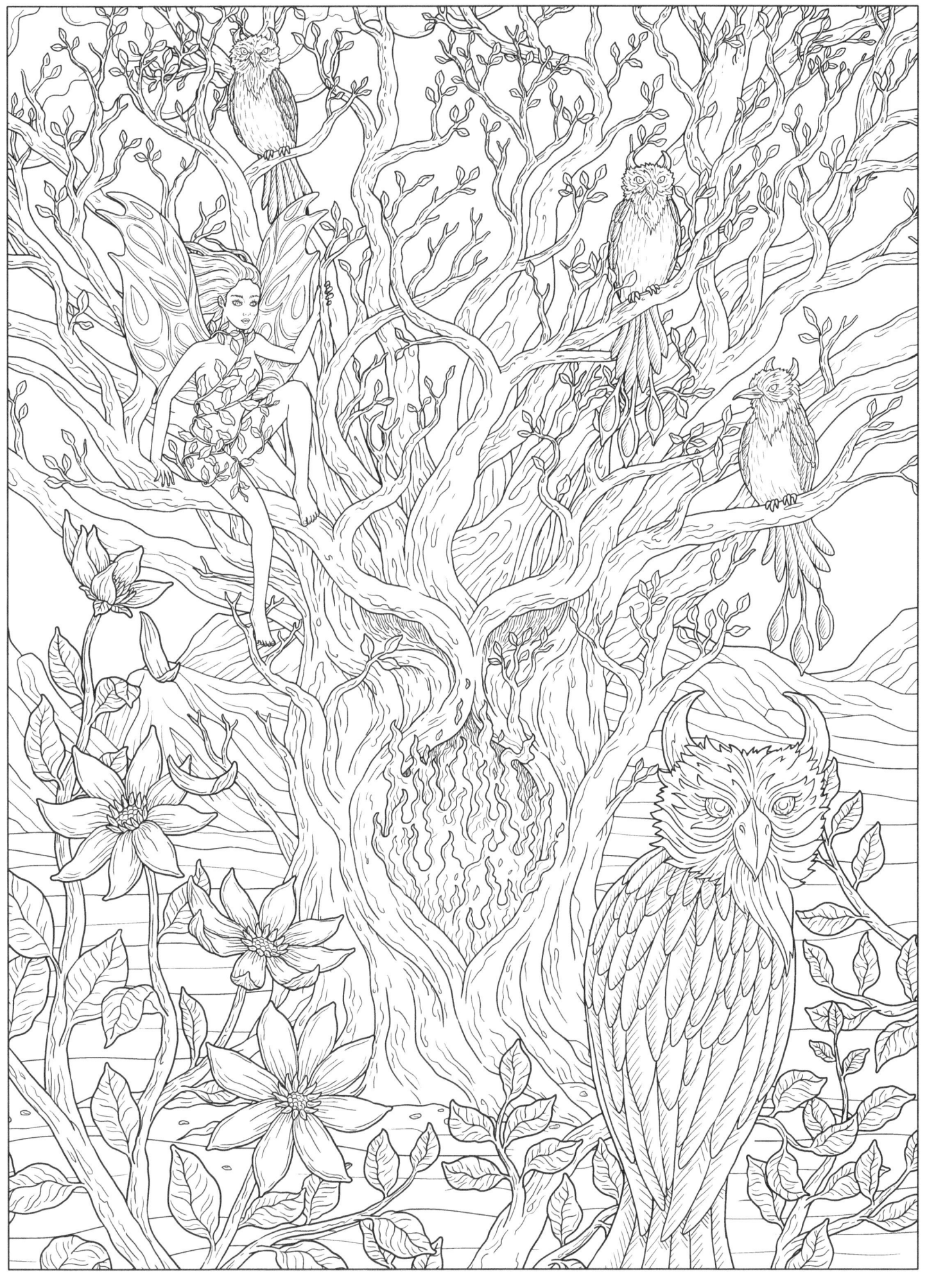

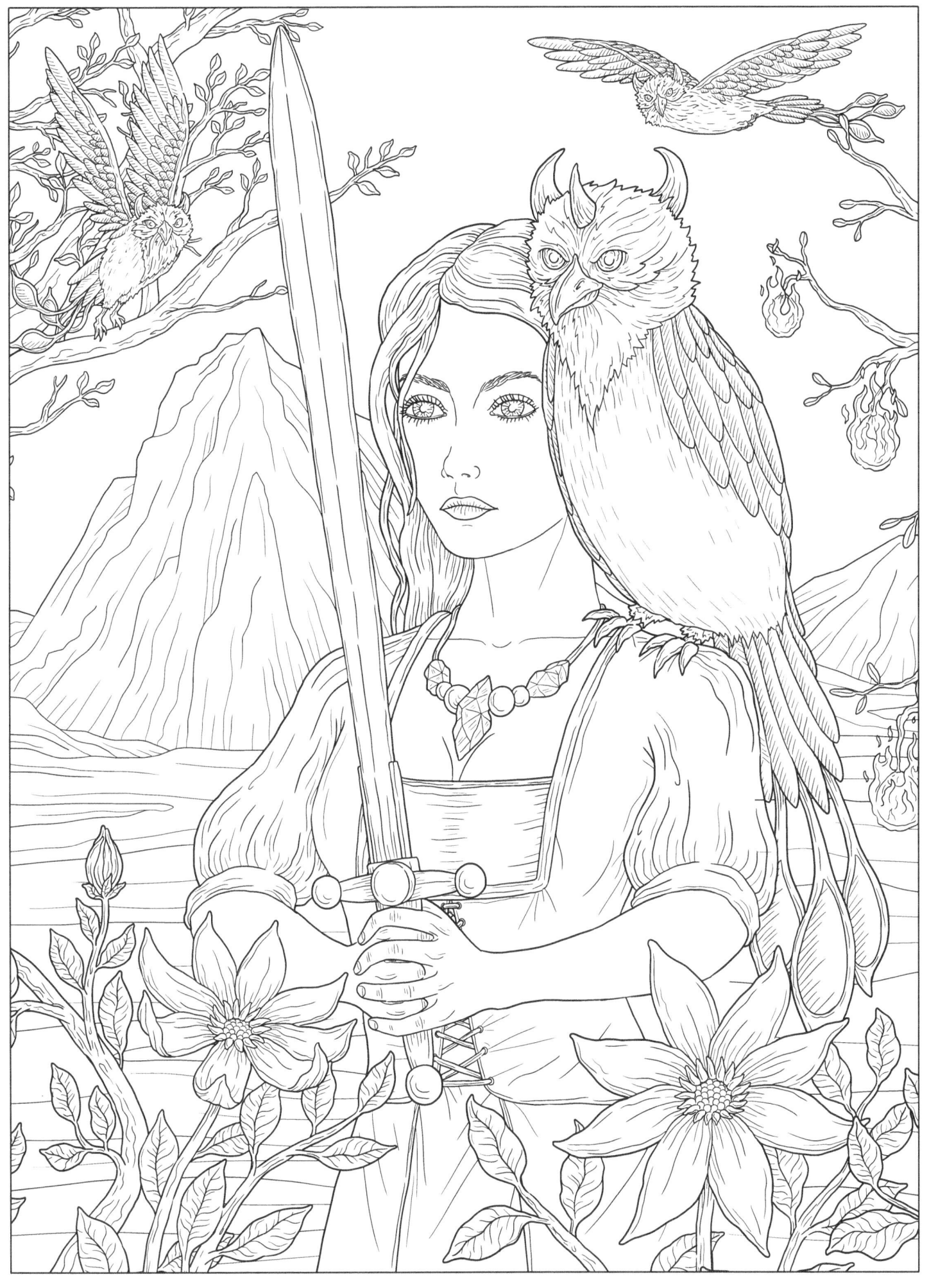

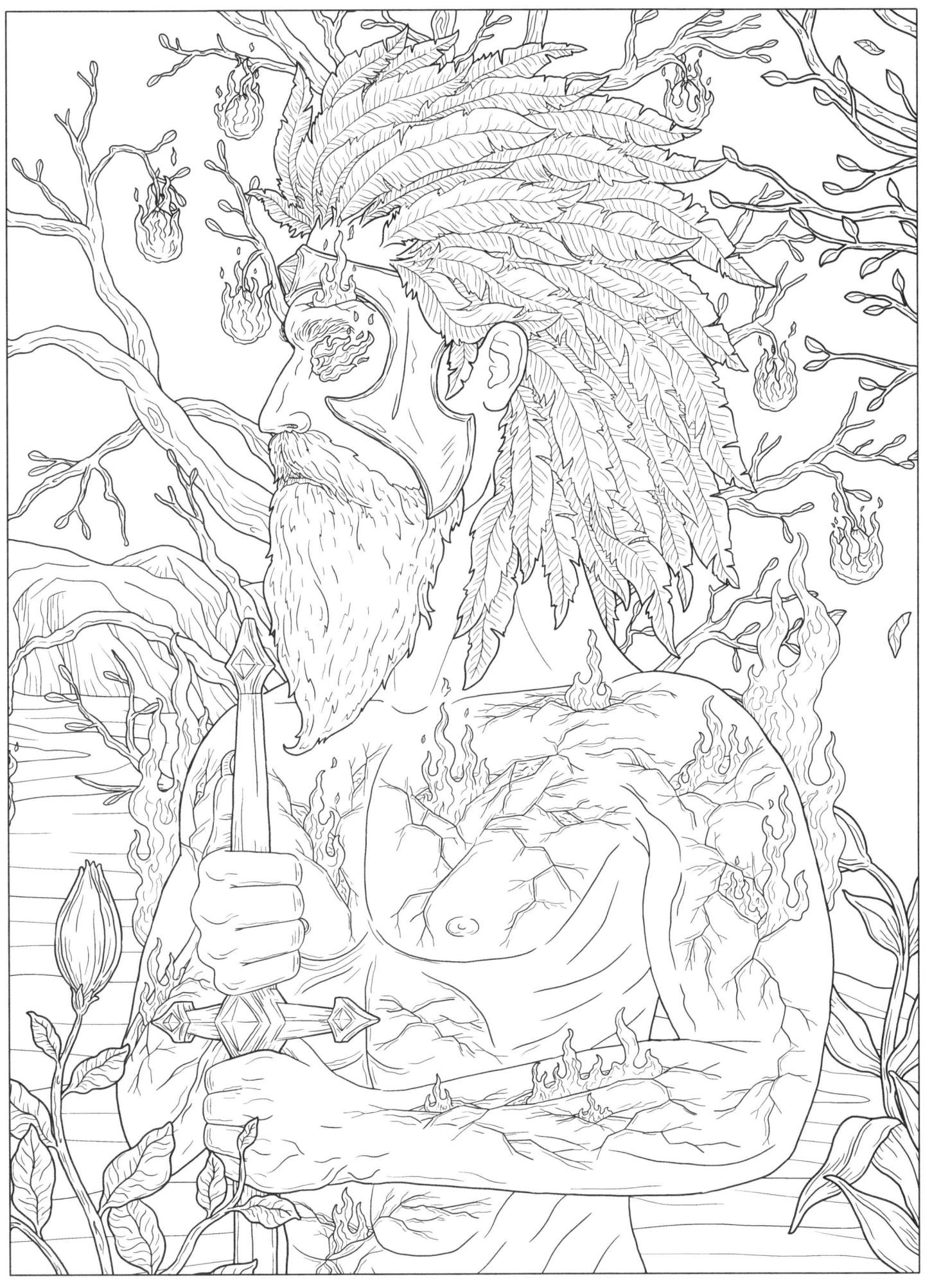

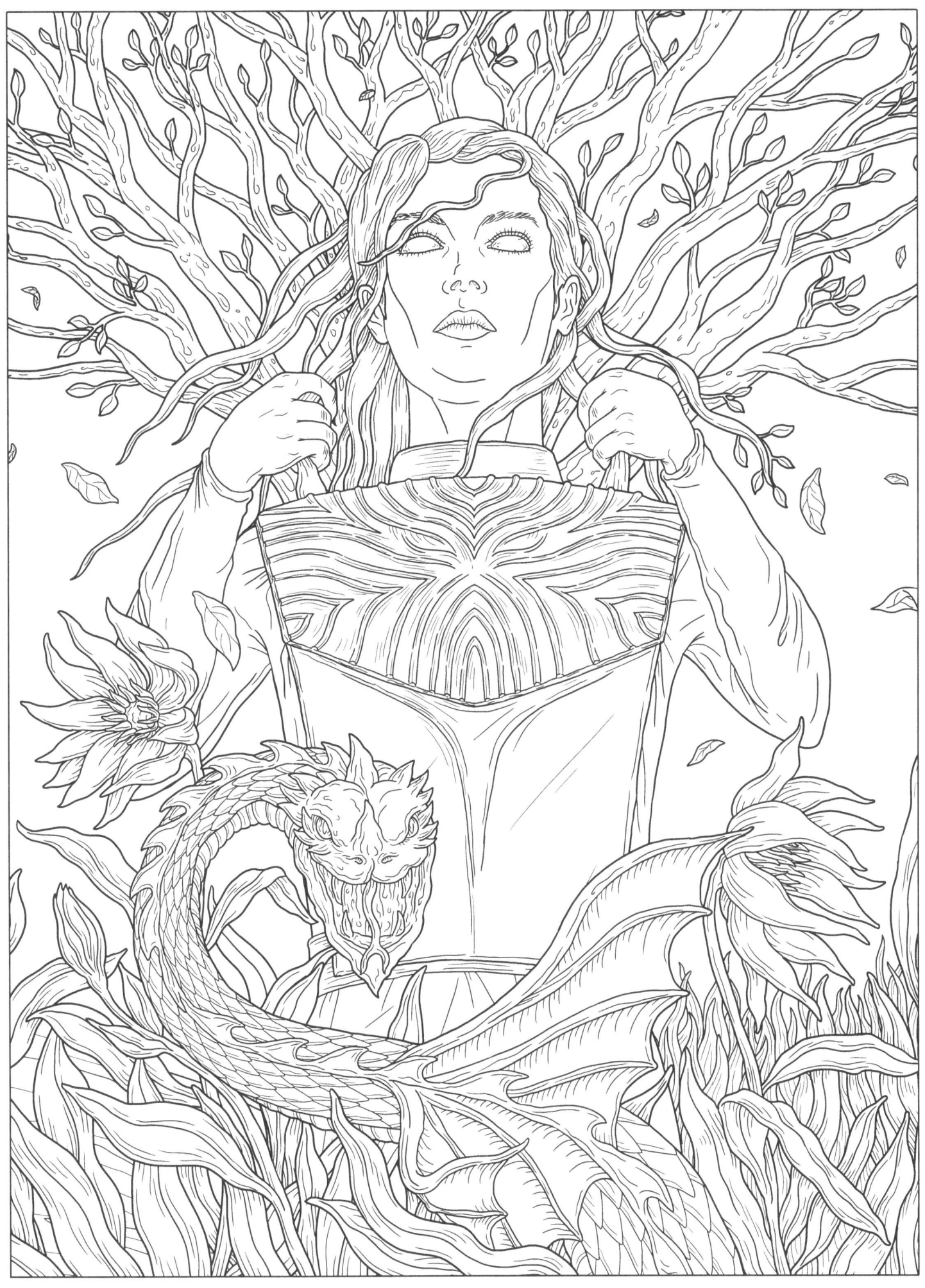

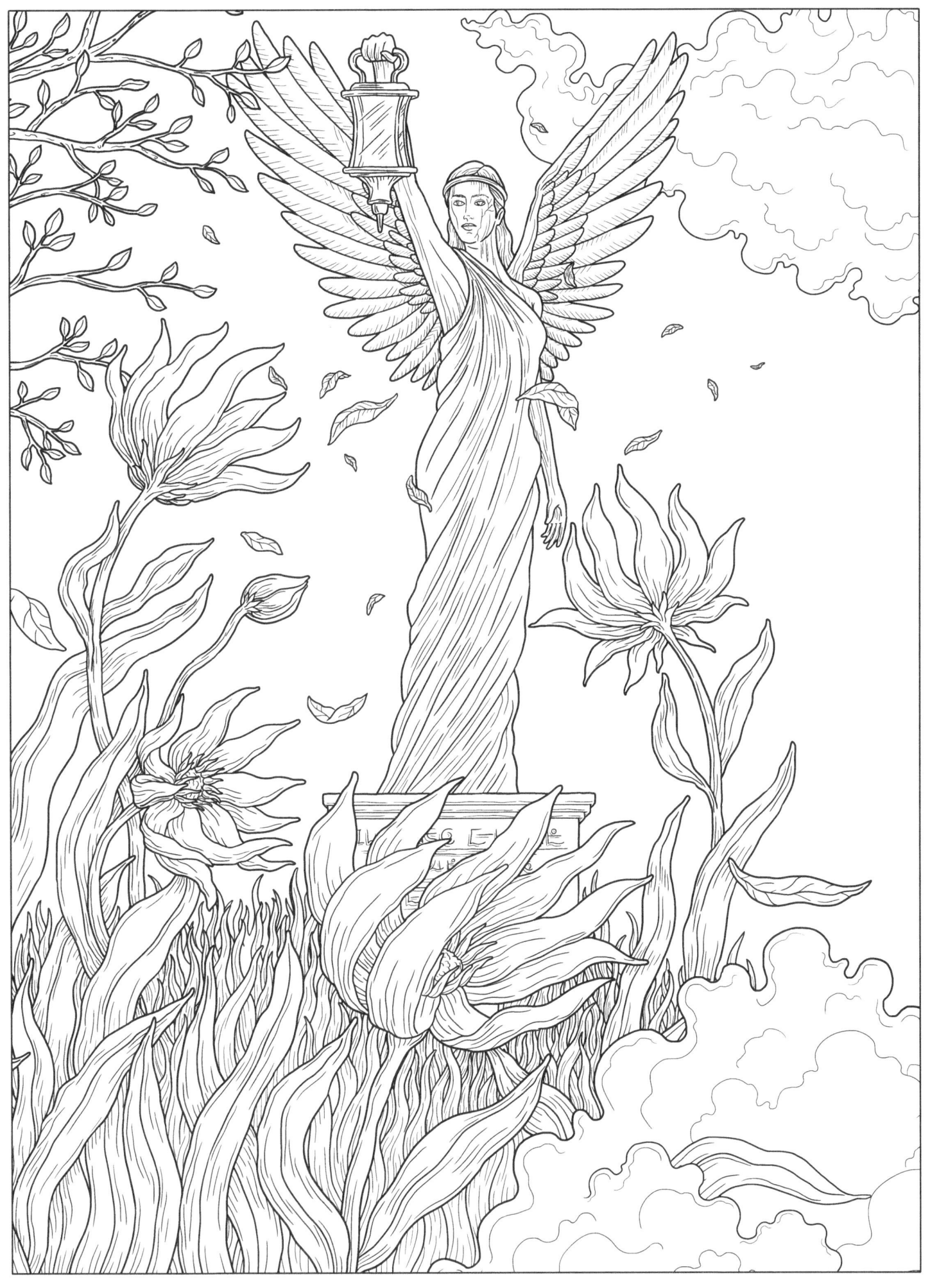

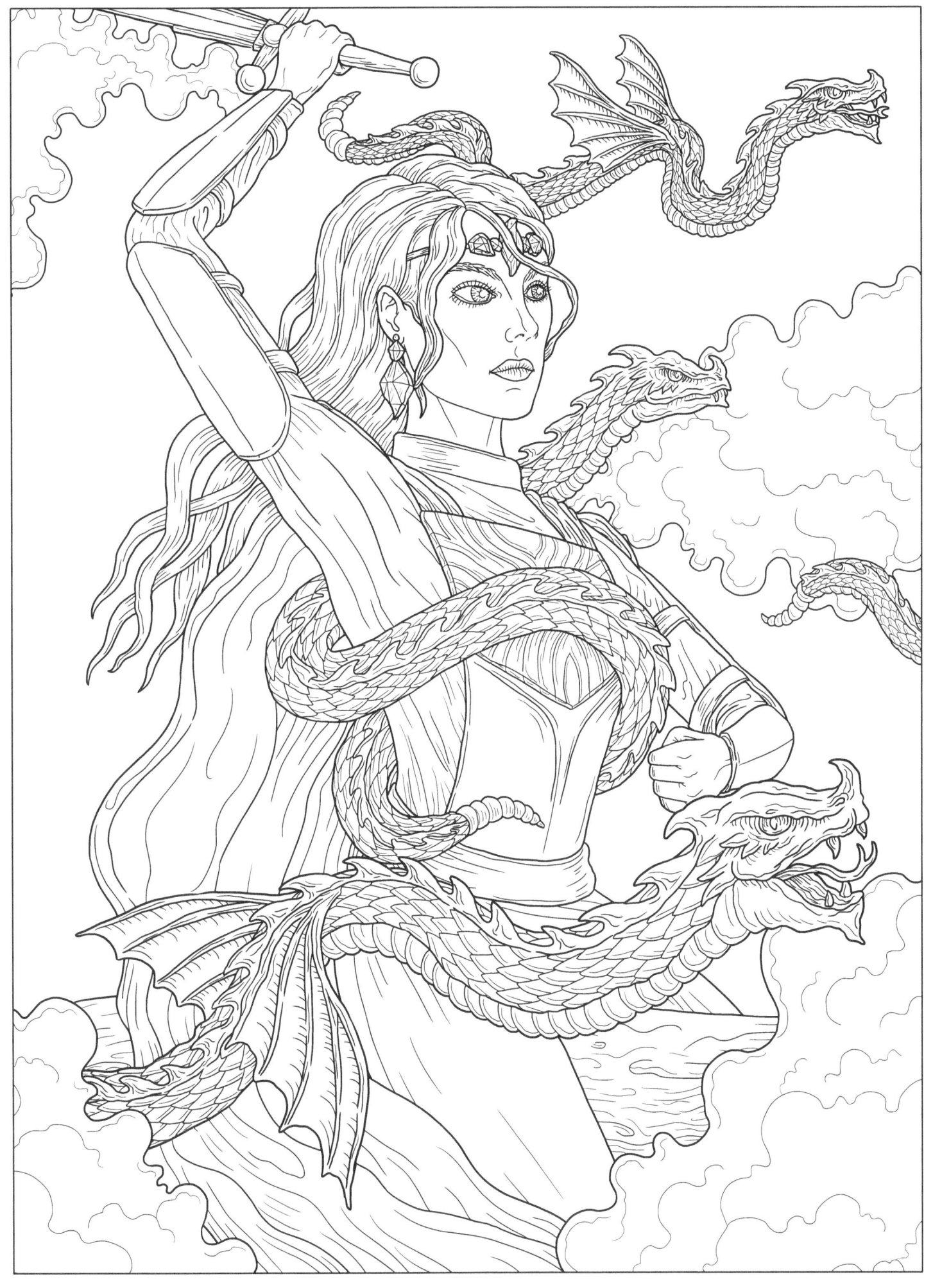

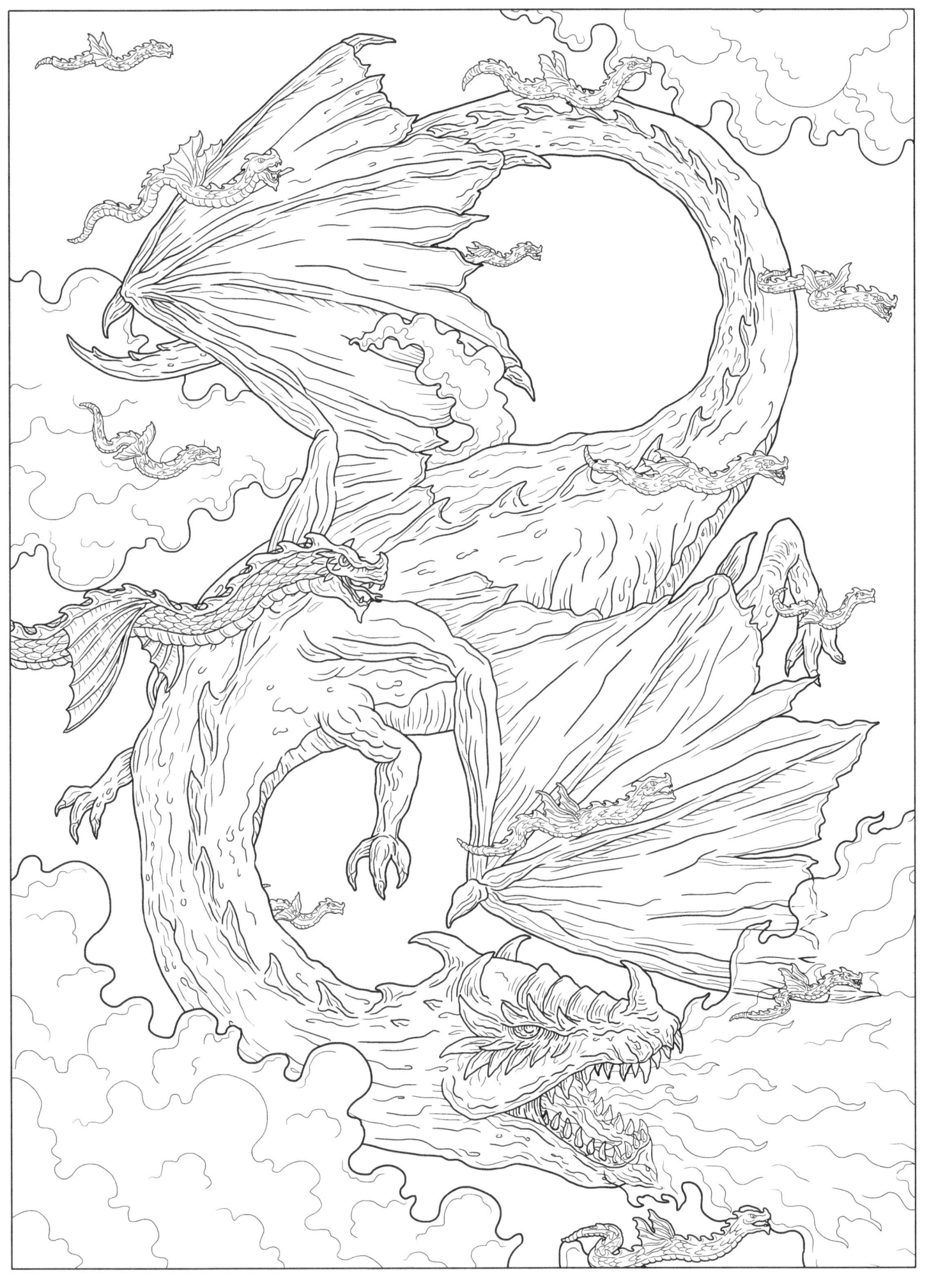

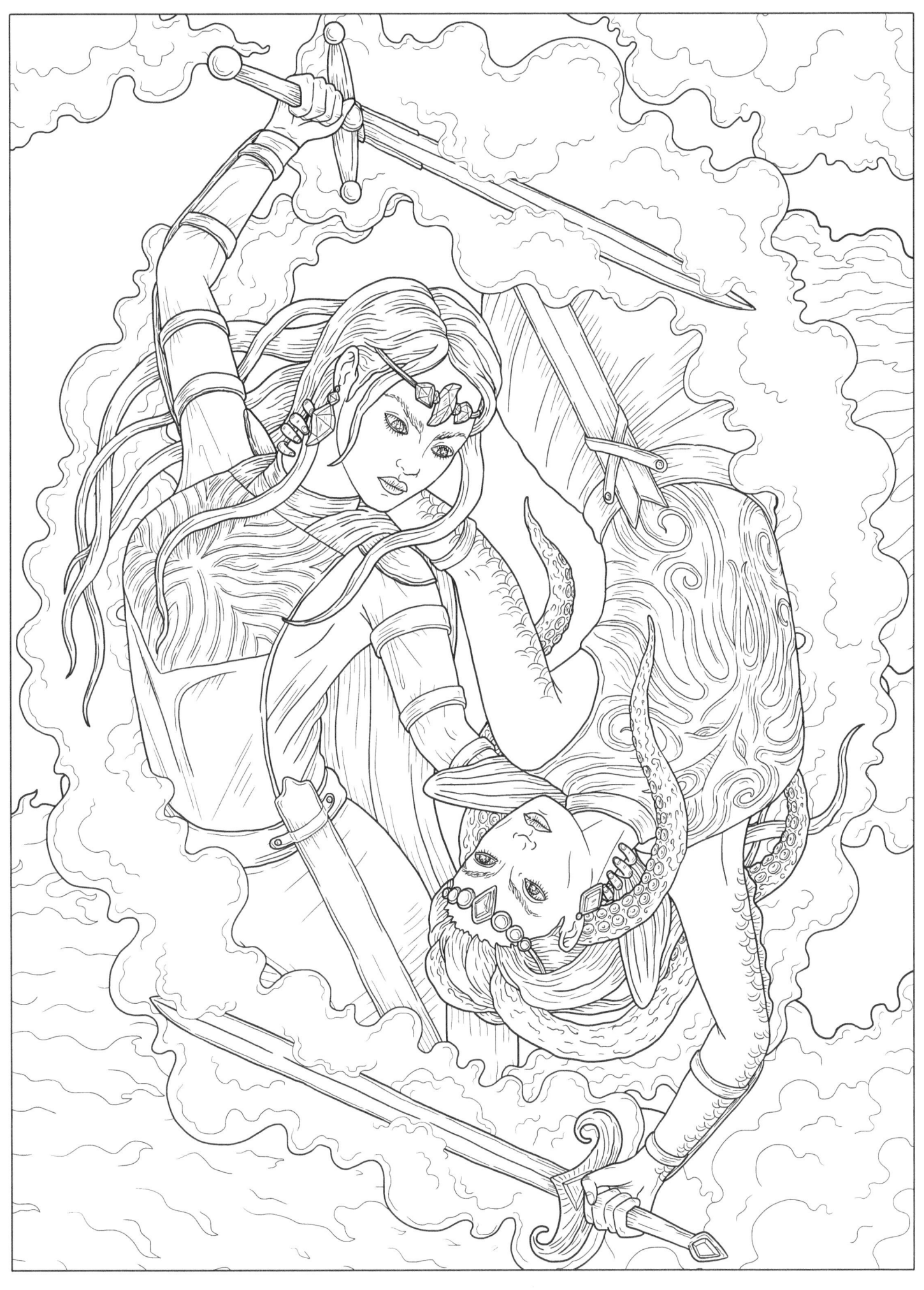

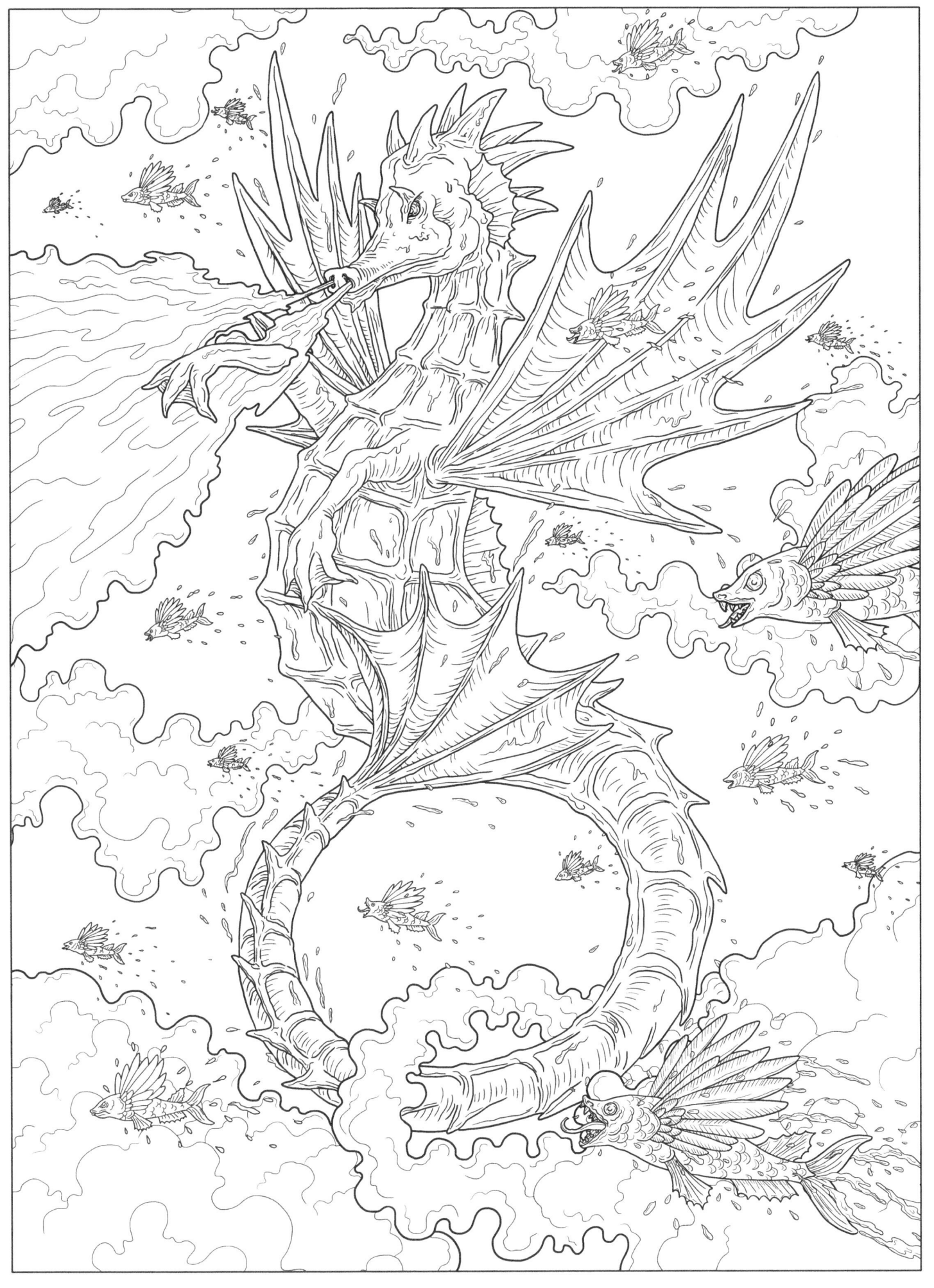

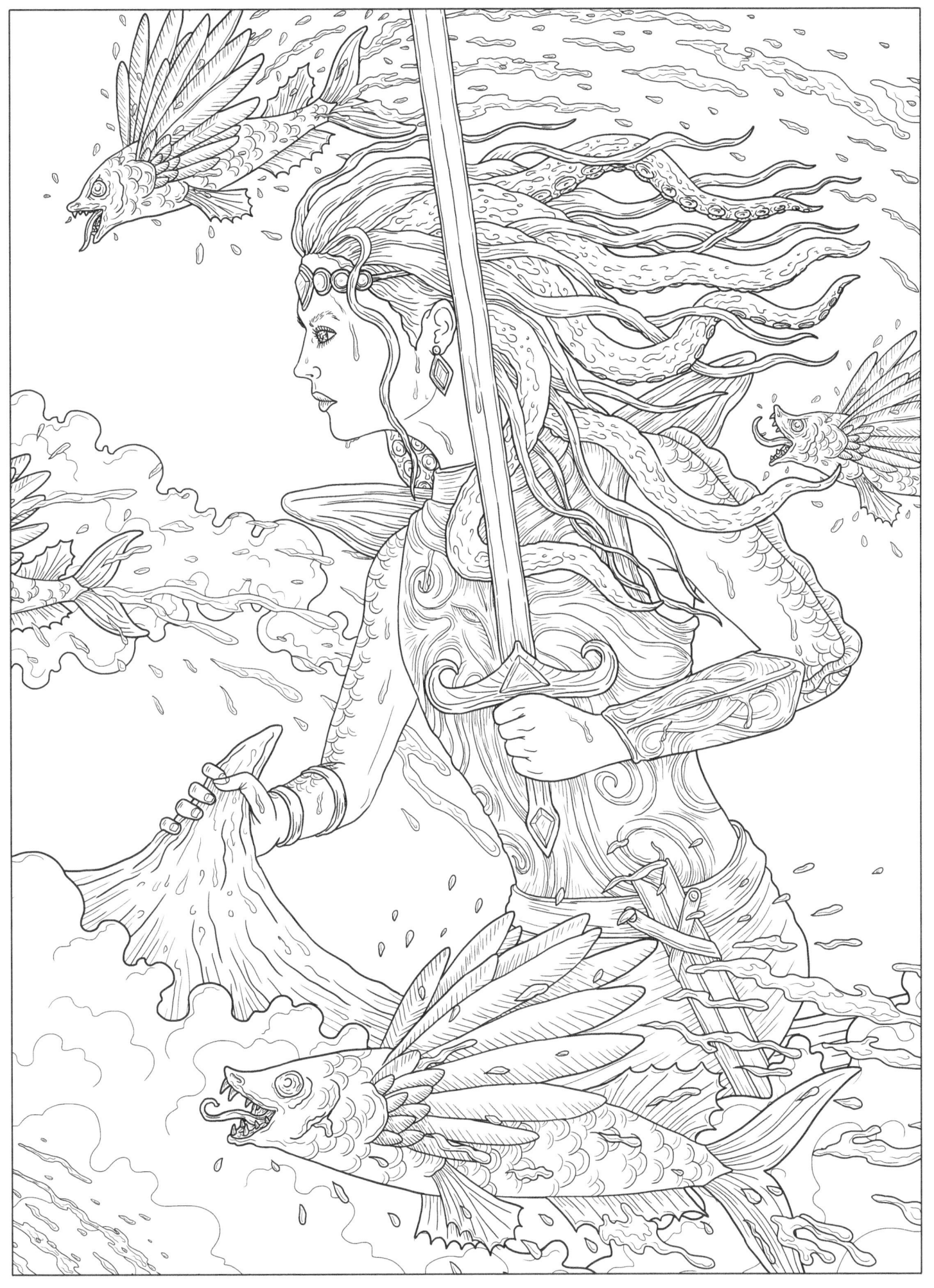

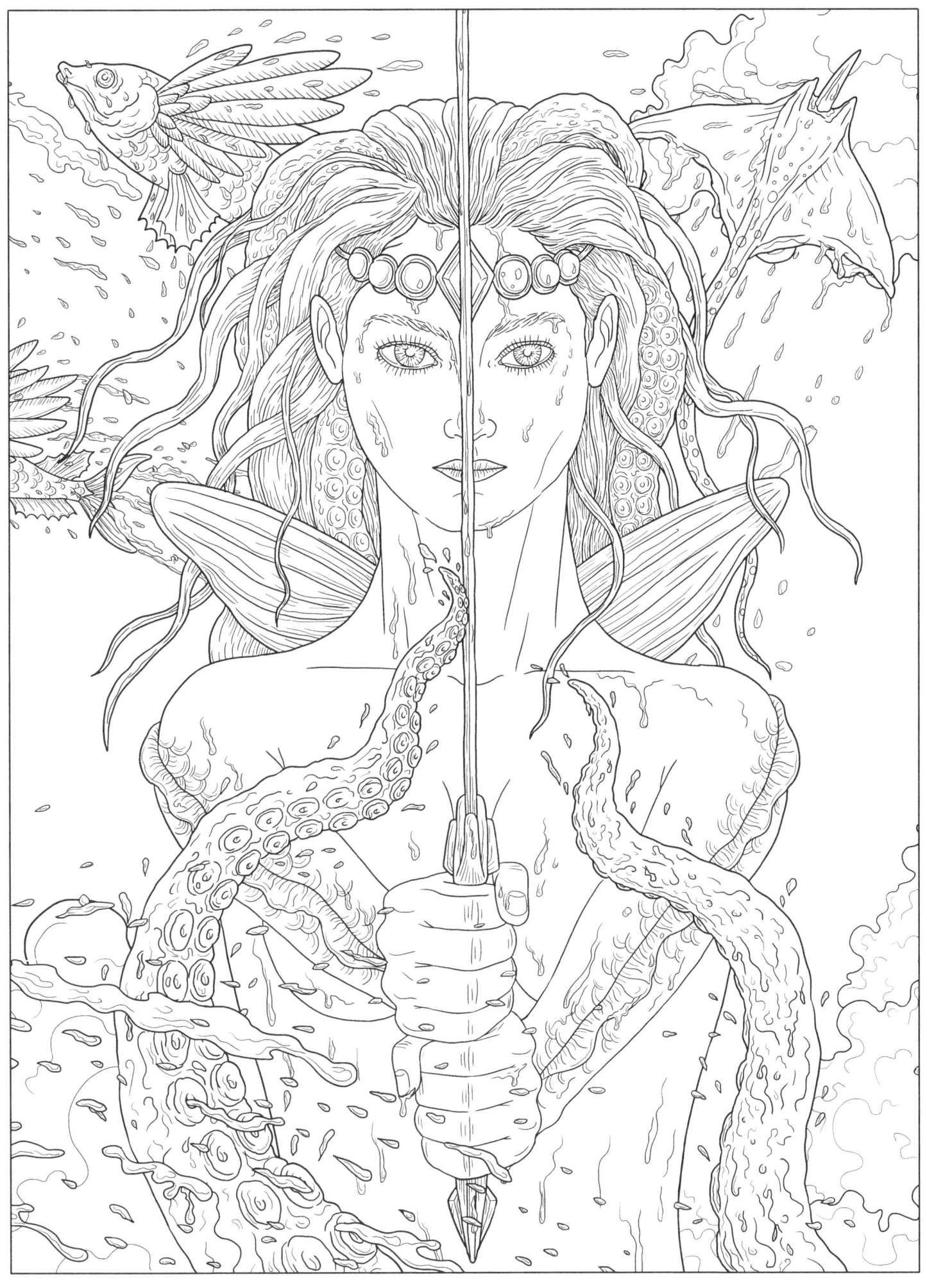

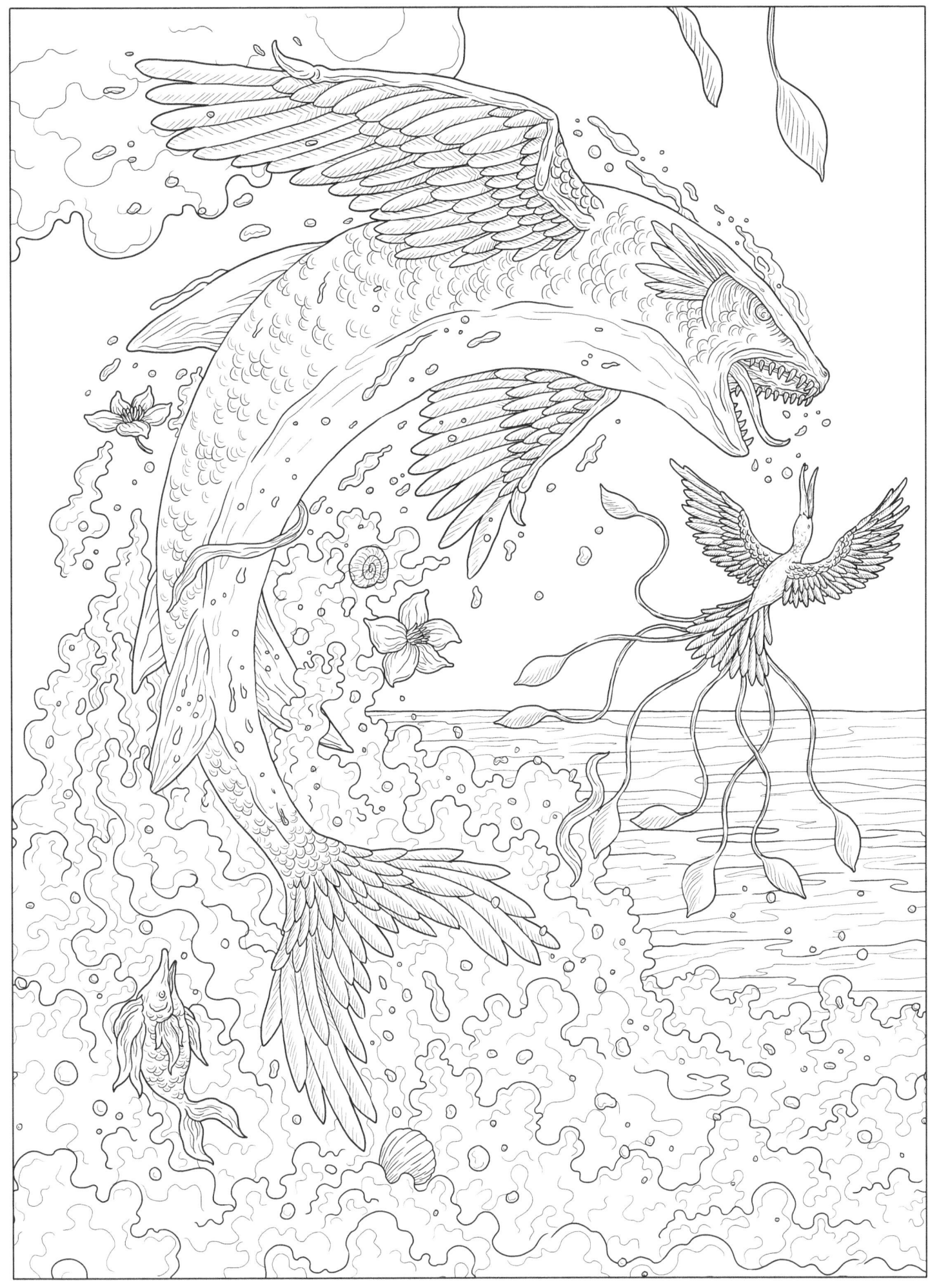

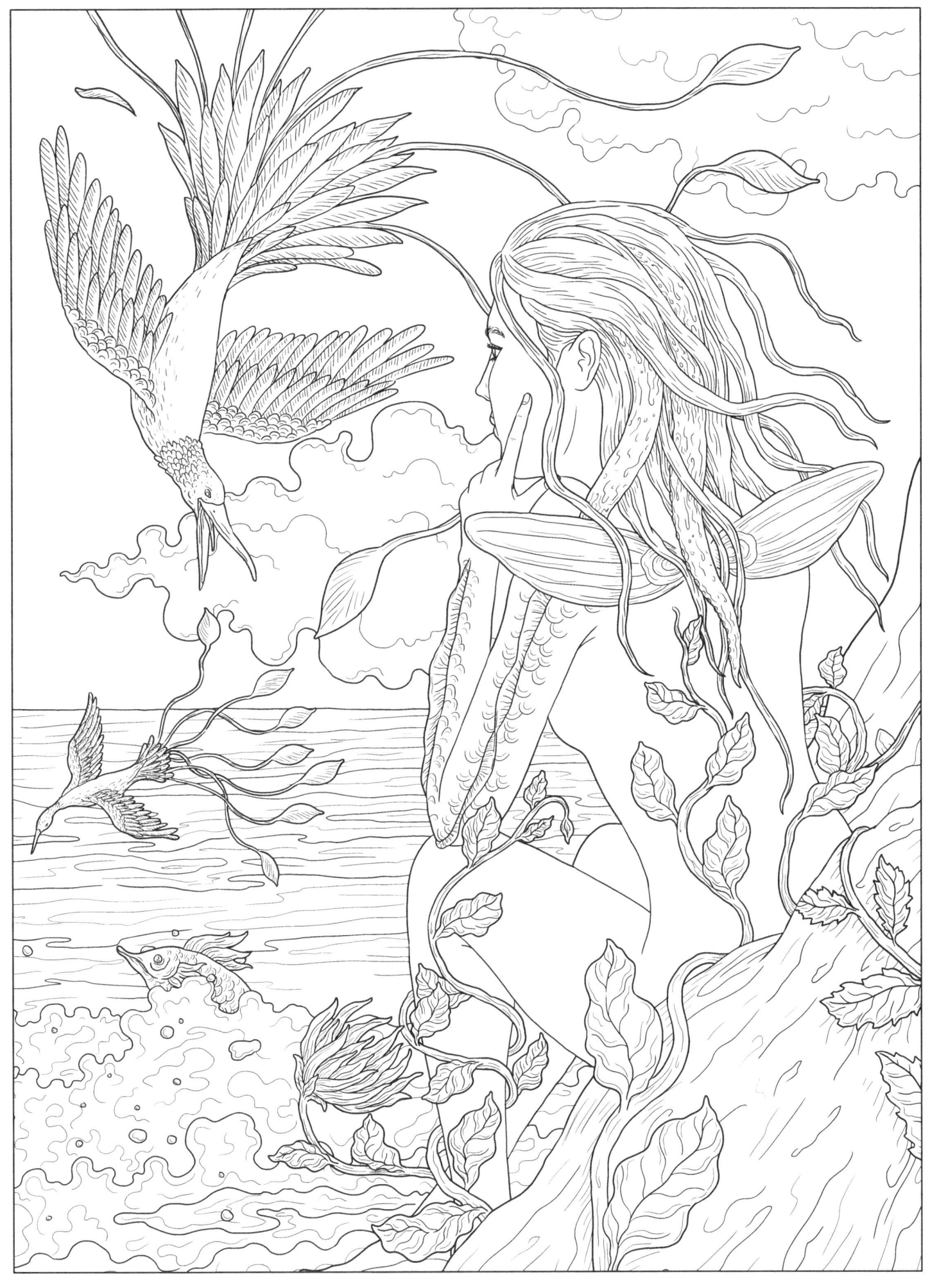

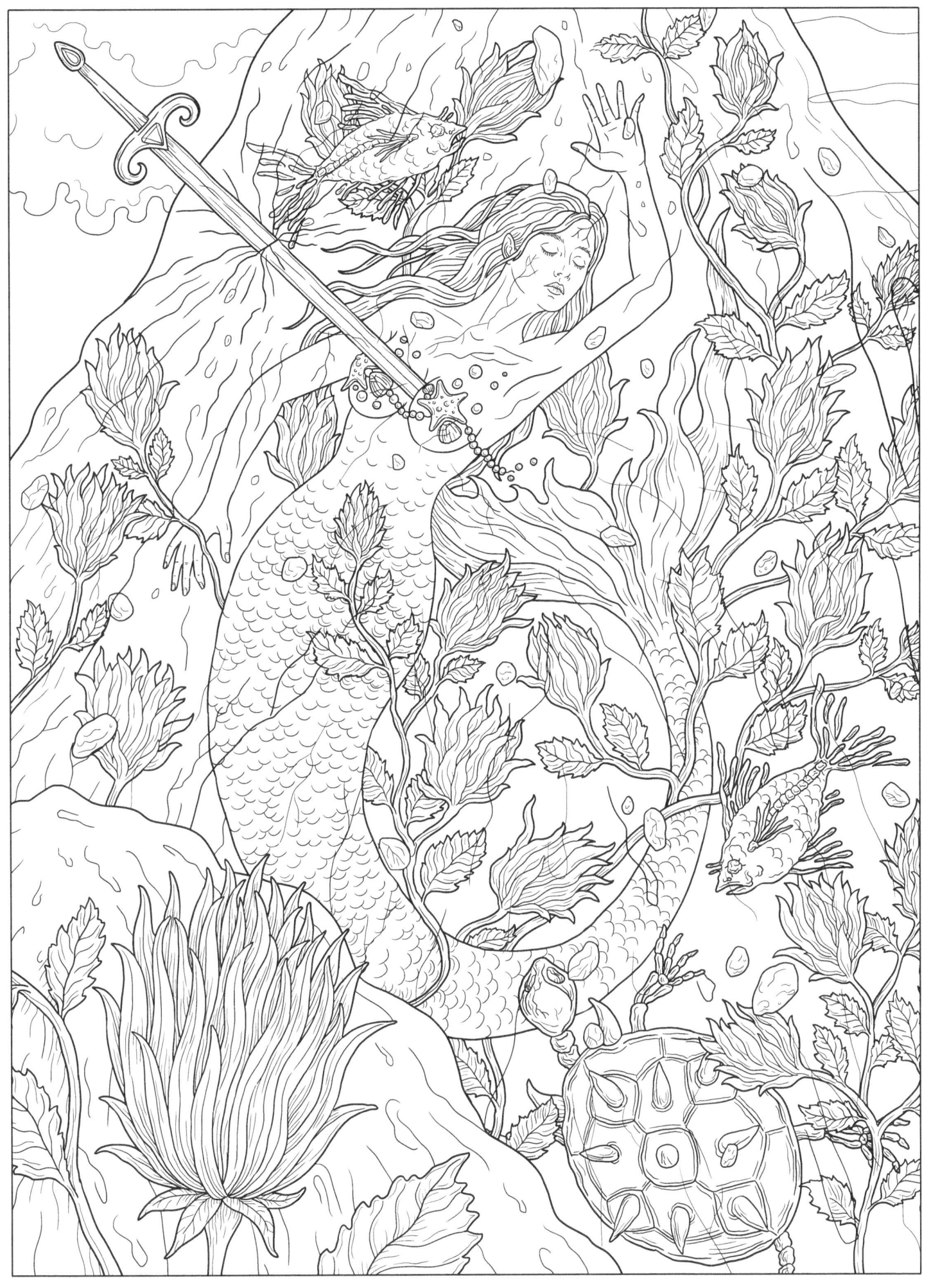

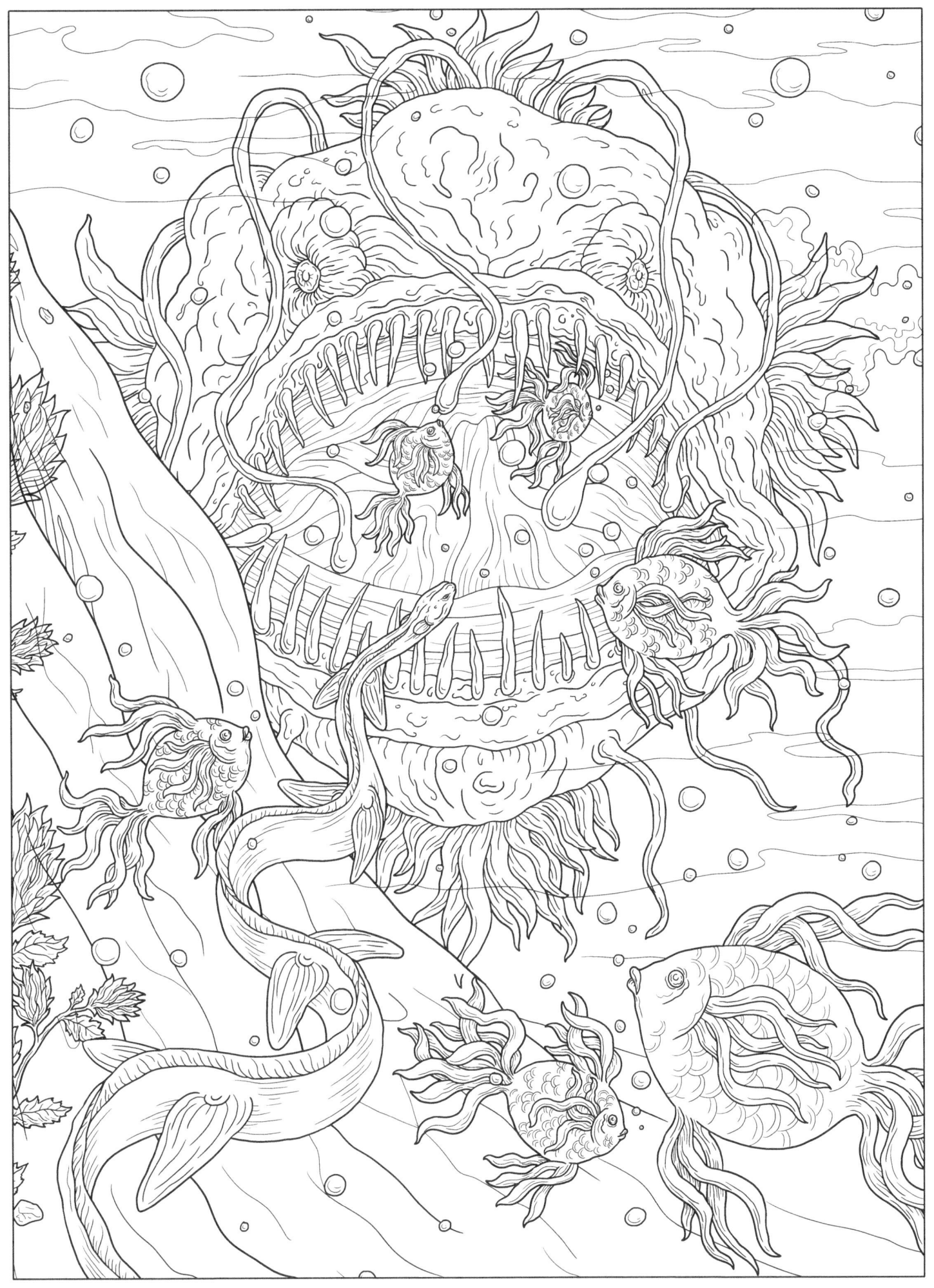

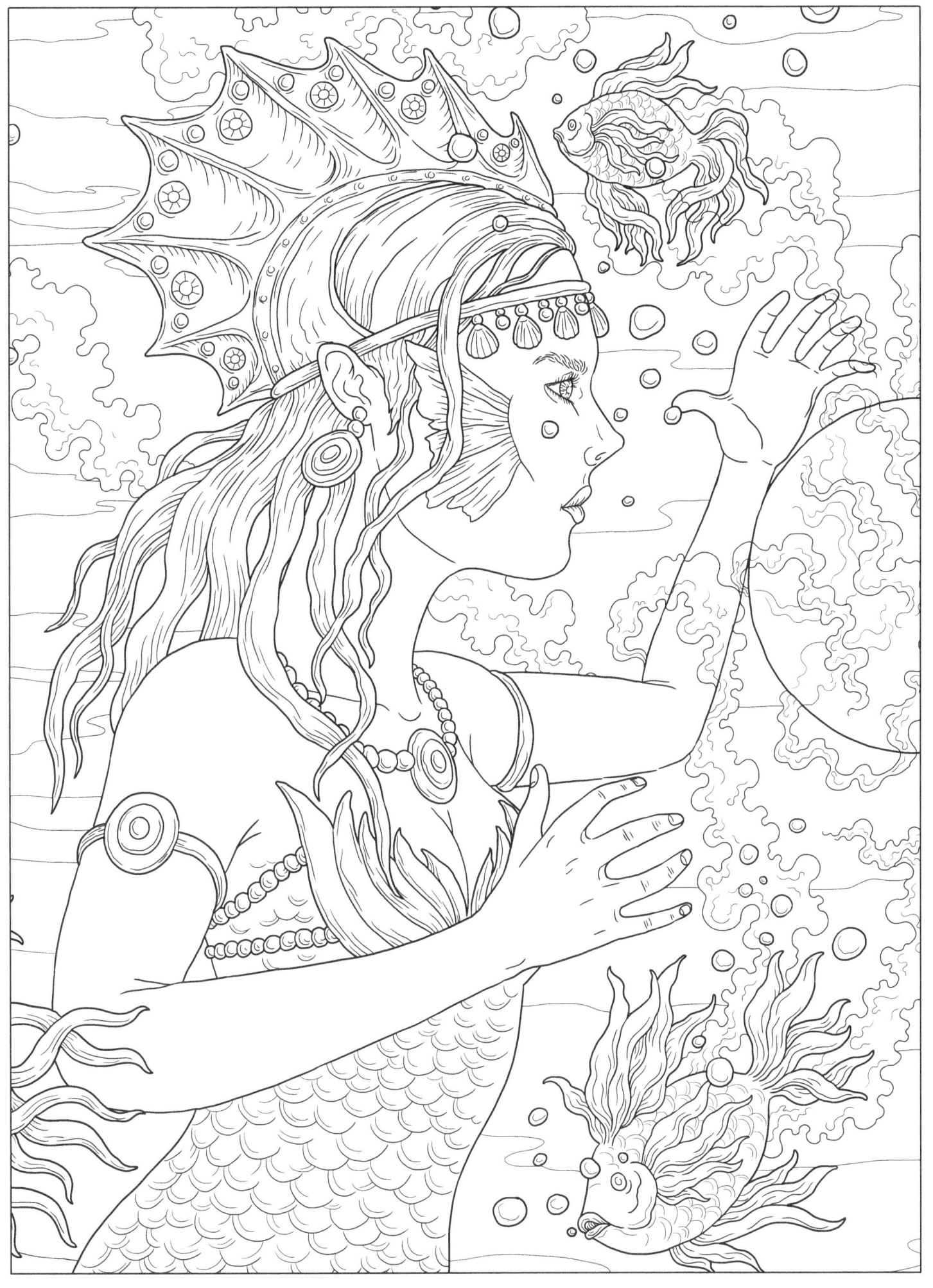

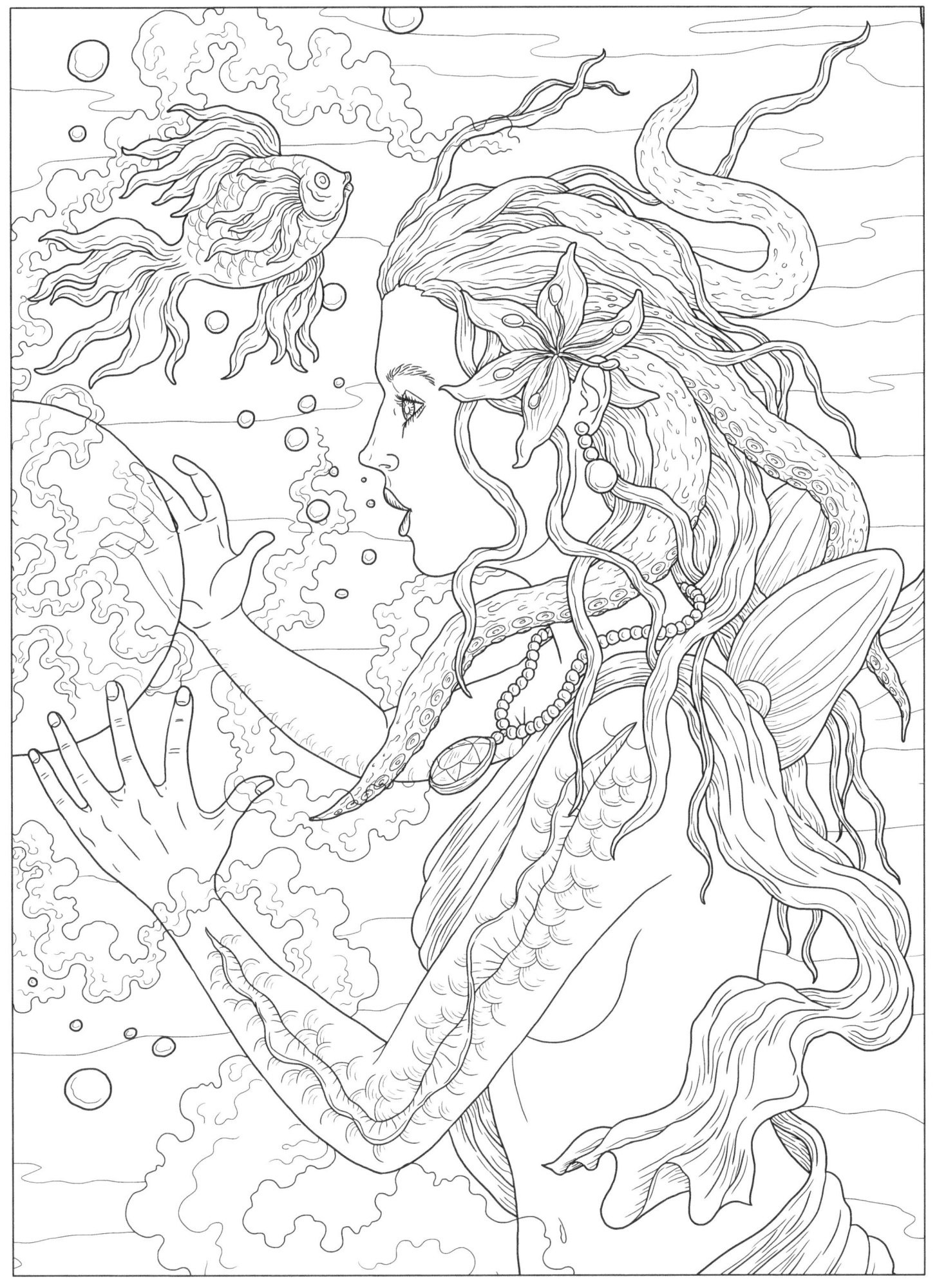

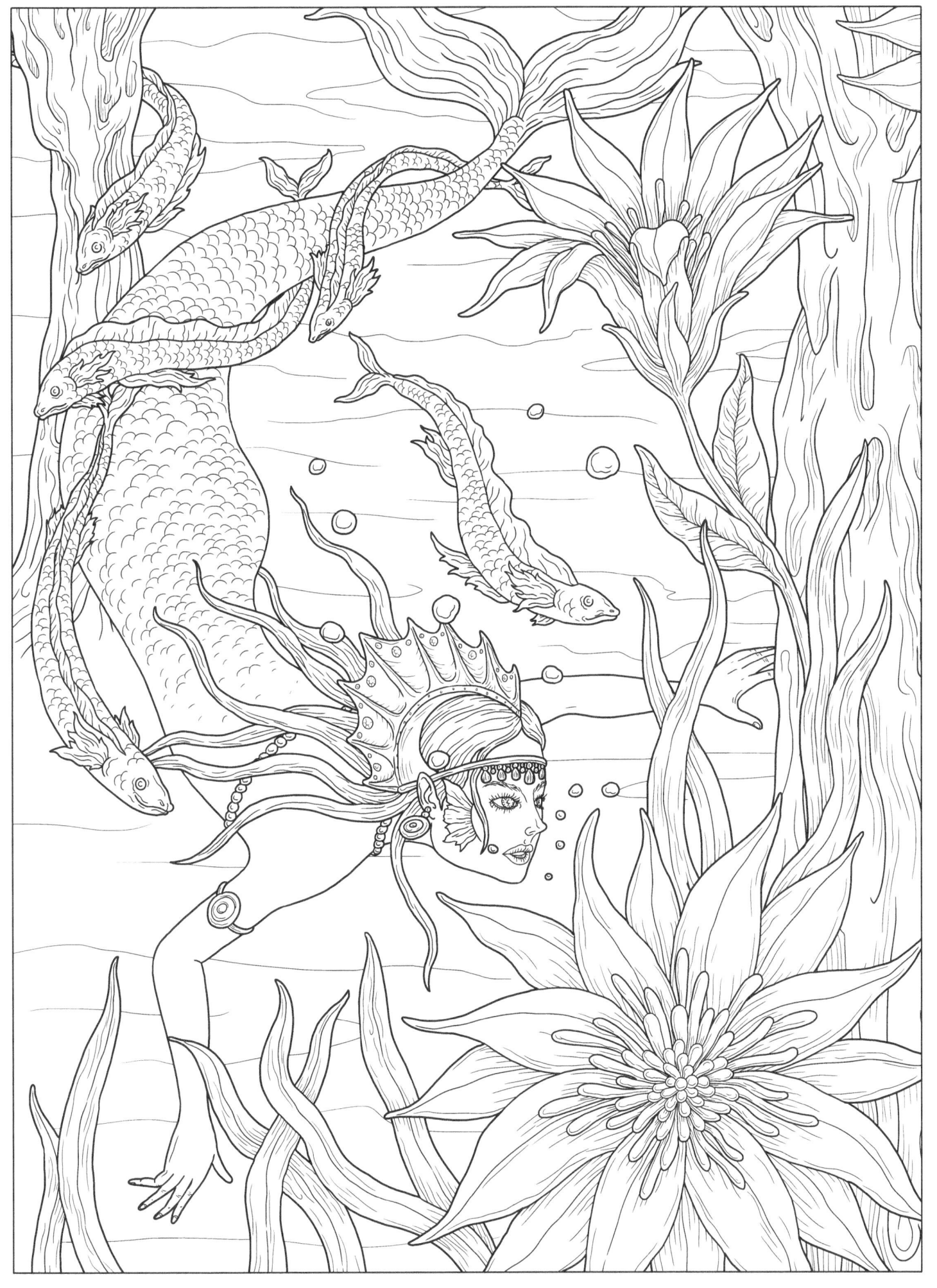

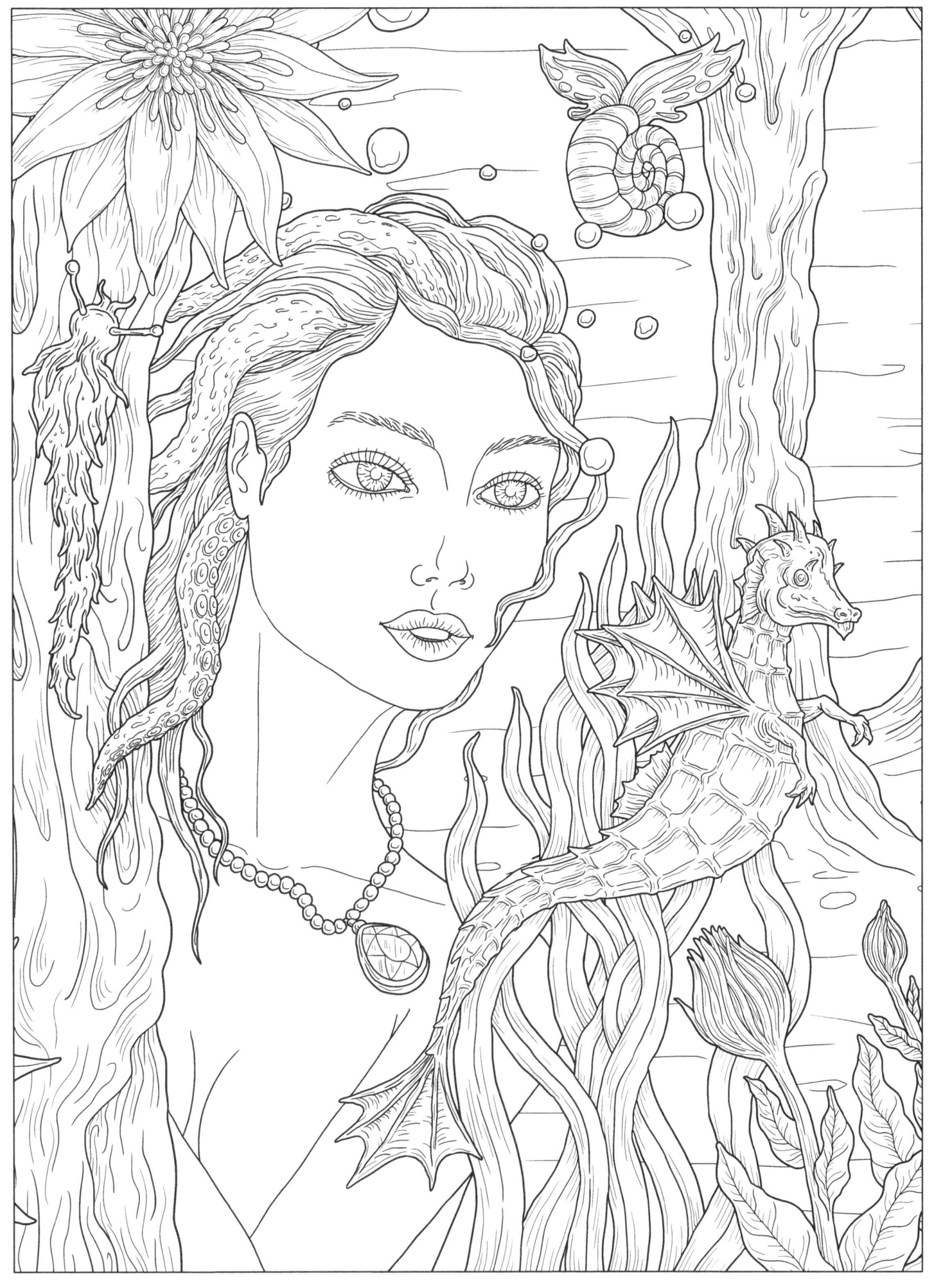

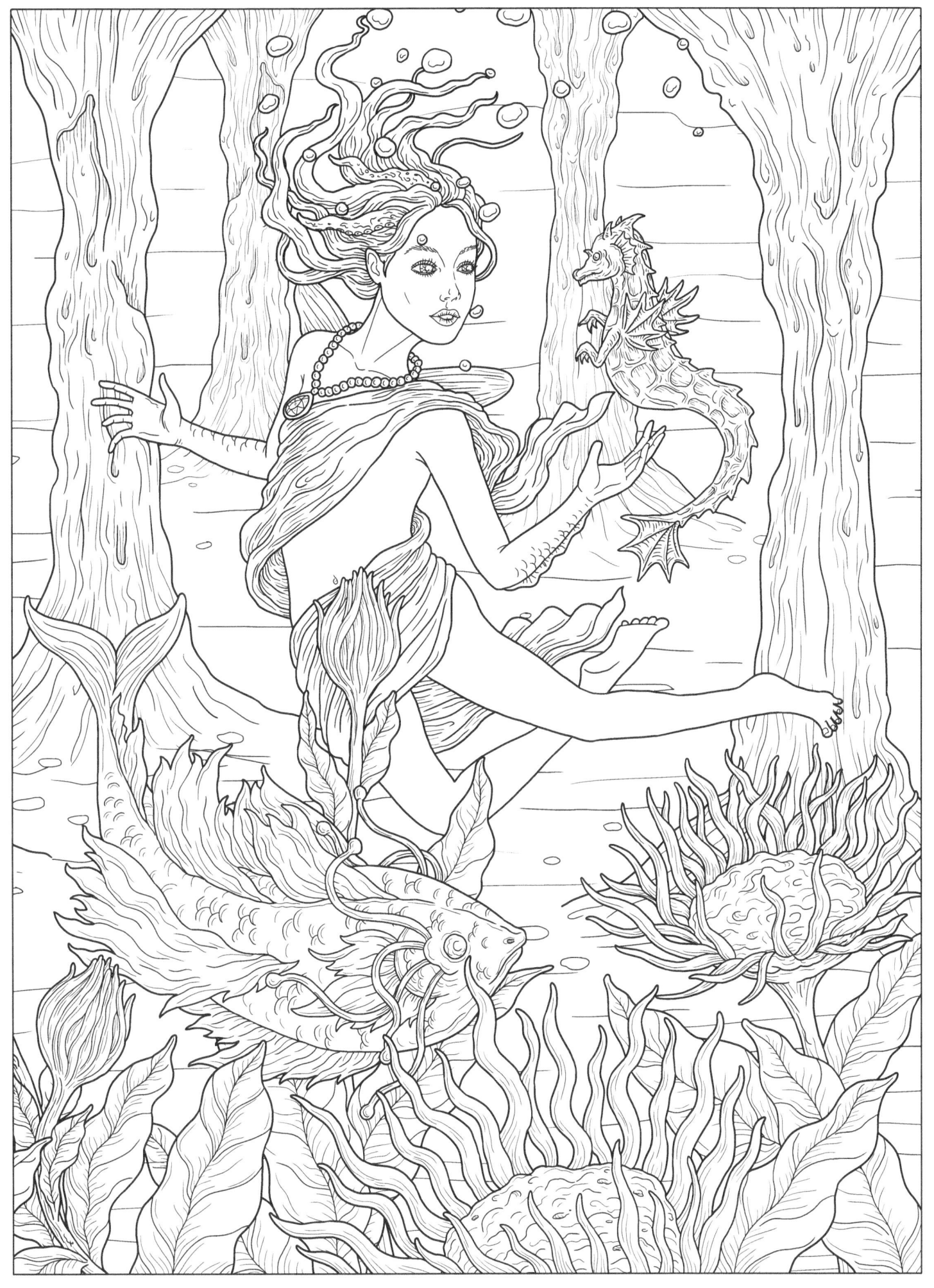

ALSO AVAILABLE FROM VIVID PUBLISHERS

August Reverie

August Reverie 2: Epic

Art Movements Series: Renaissance

August Reverie 3: Expressions

Wild Fantasm

Gods & Goddesses

Preview all the pages at www.vividpublishers.com/books

Hepatica Dream
From August Reverie

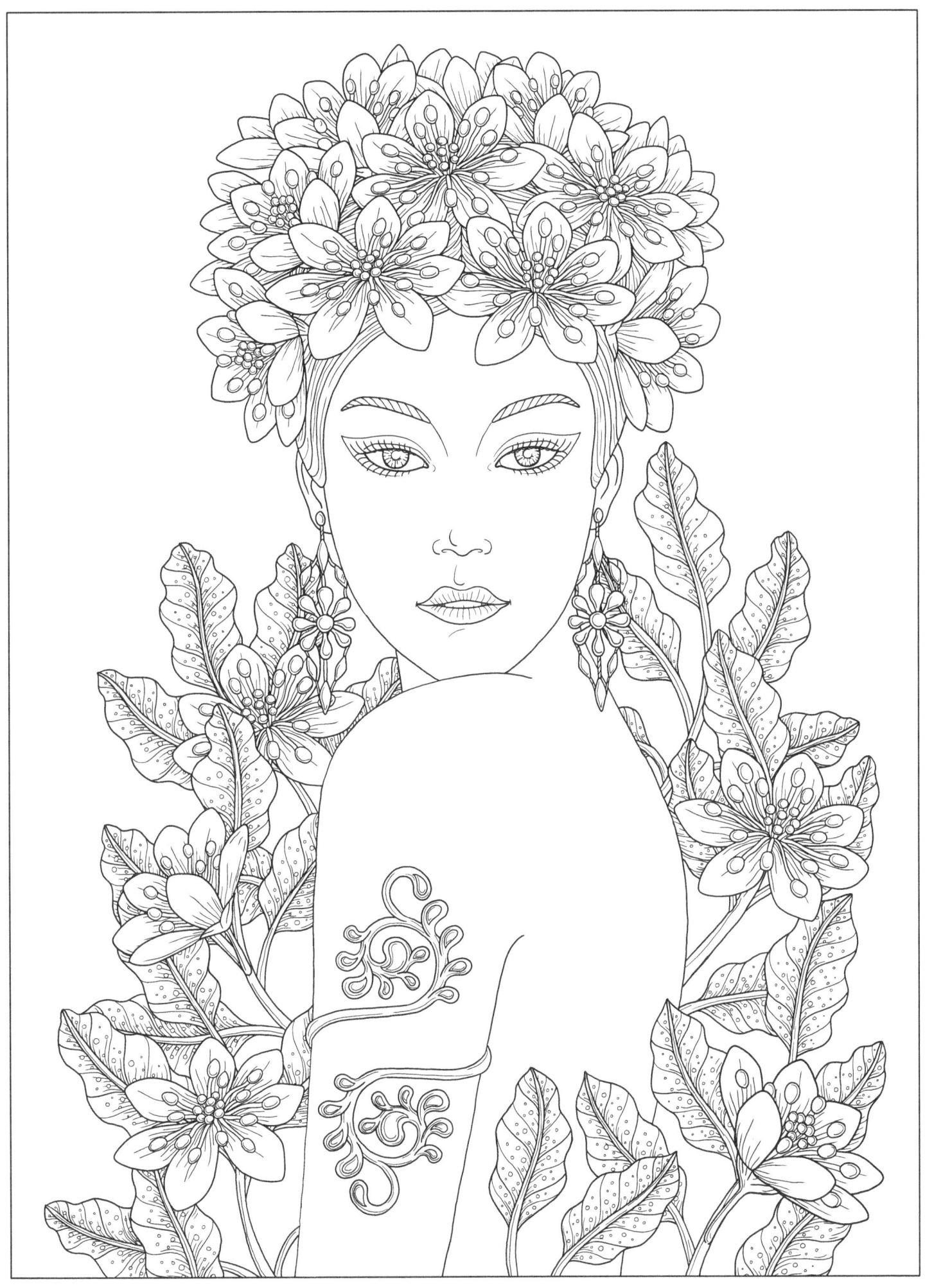

Of Thorns & Roses
From August Reverie 2: Epic

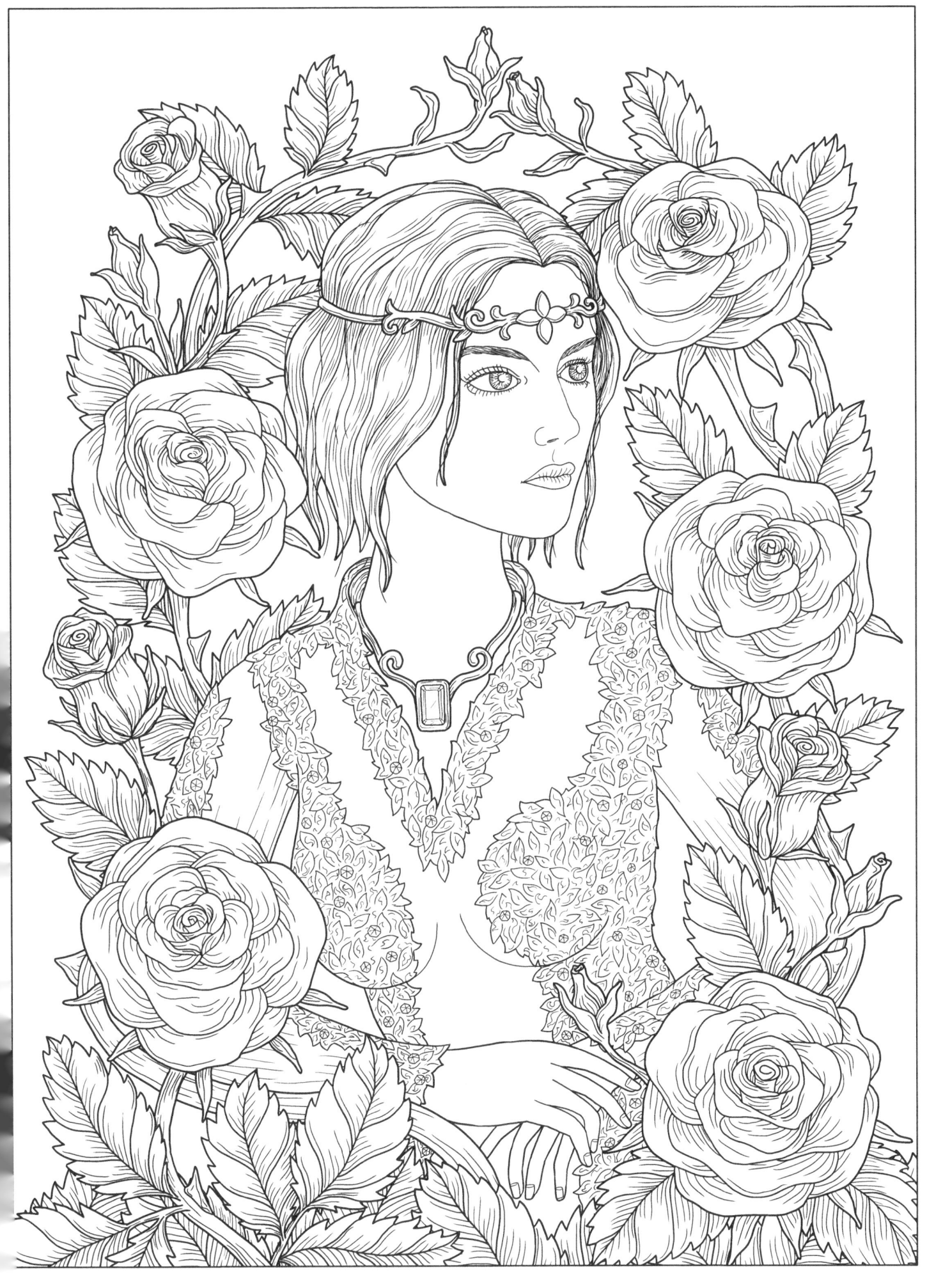

www.ingramcontent.com/pod-product-compliance
Lightning Source LLC
Chambersburg PA
CBHW080133240526
45468CB00009BA/2411